random

rue

random

/ Randəm /

Learn how to pronounce

adjective

 1. 1 .

made, done, or happening without a method or conscious decision.

"apparently random violence"

noun

INFORMAL

 1. 1 .

an unknown, unspecified, or odd person.

"I just sat down by myself and talked to some randoms"

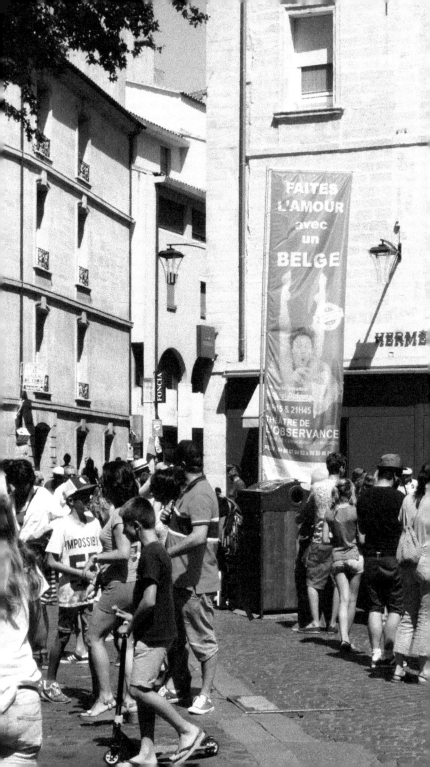

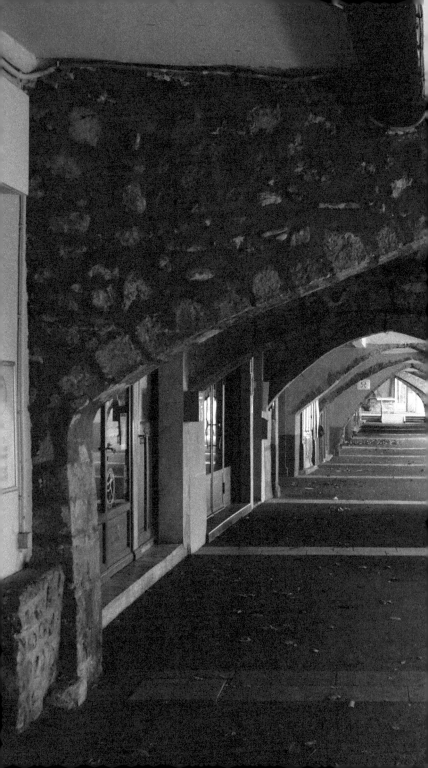

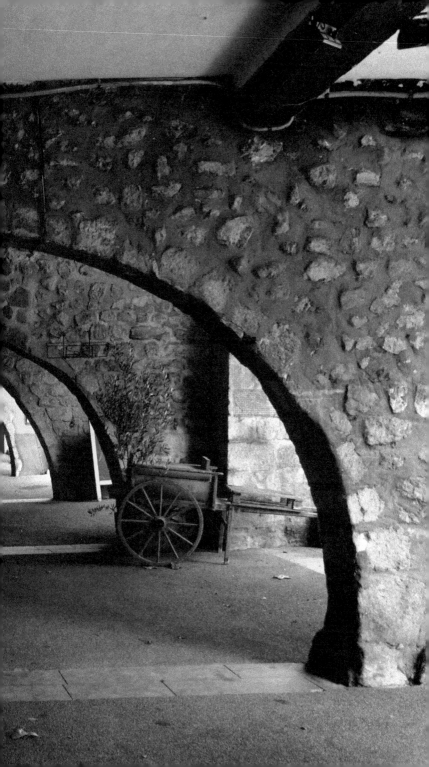

ention
Chat

ention
Chien

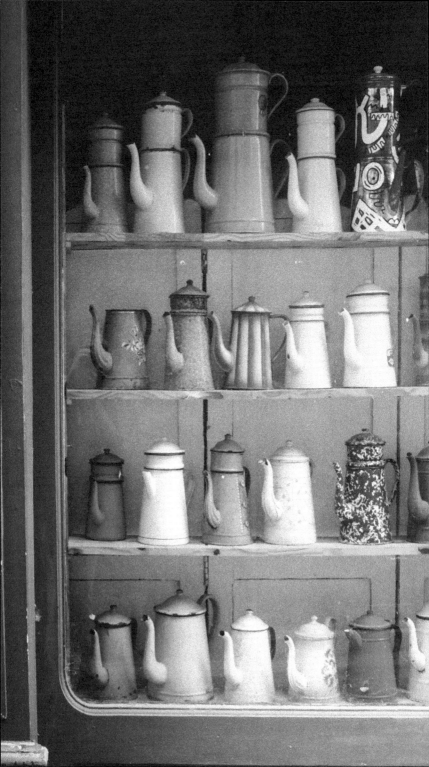

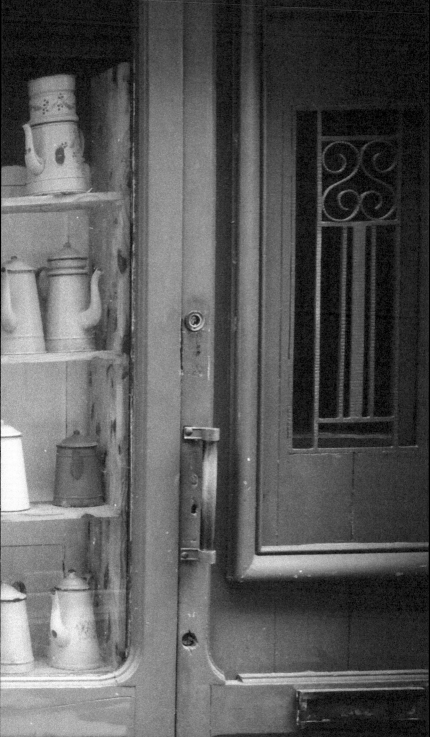

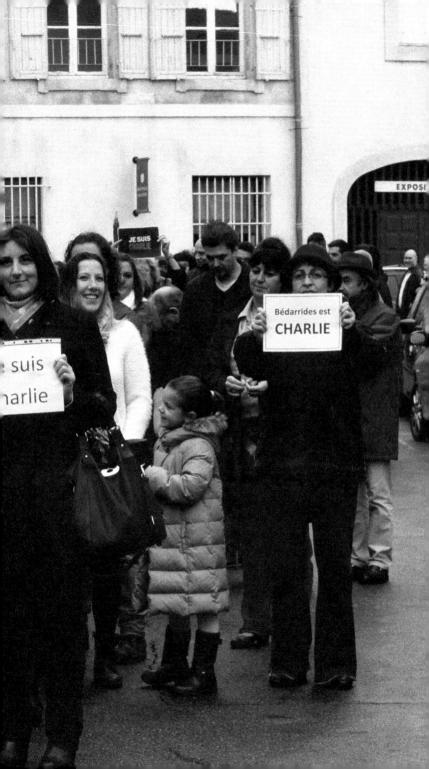

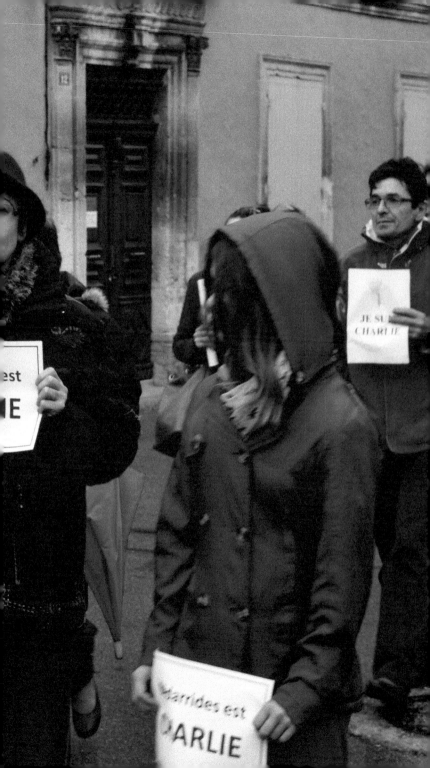

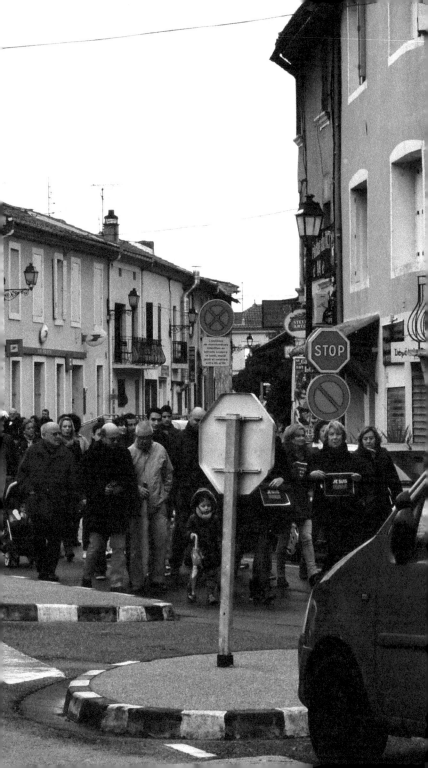

Place de l'Horloge

Chambre de Commerce
d'Industrie du Vaucluse

La Poste

Office de Tourisme

HEVAL
ASSION

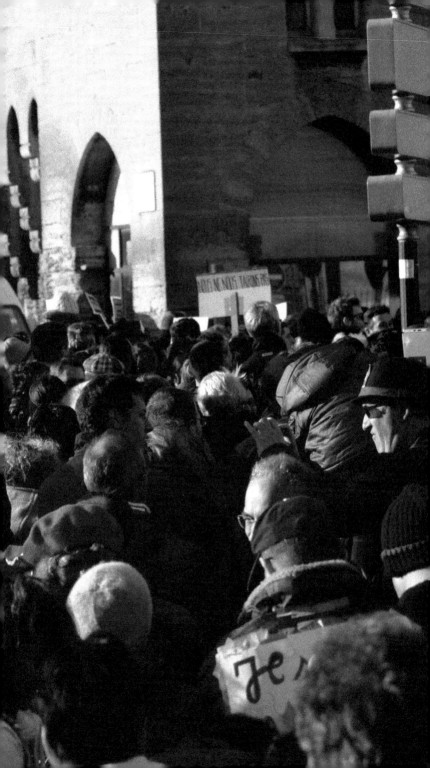

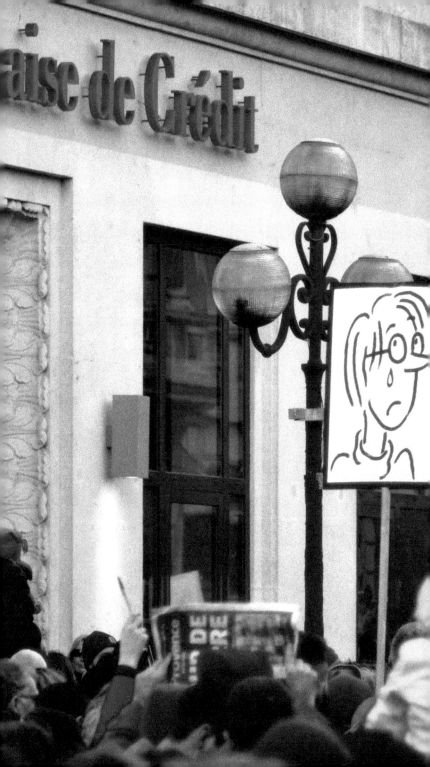

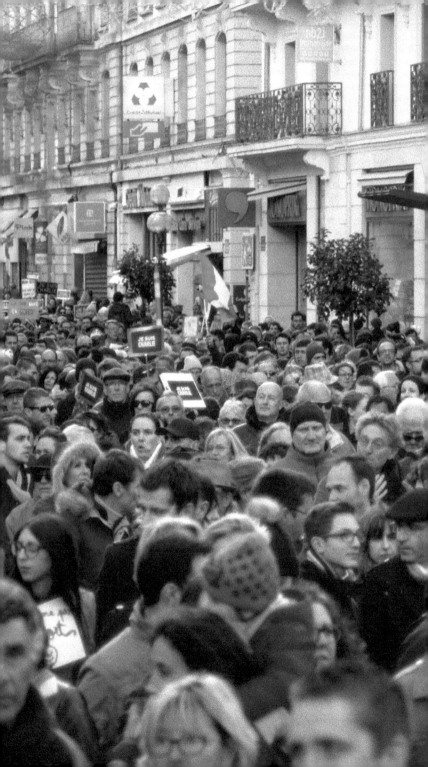

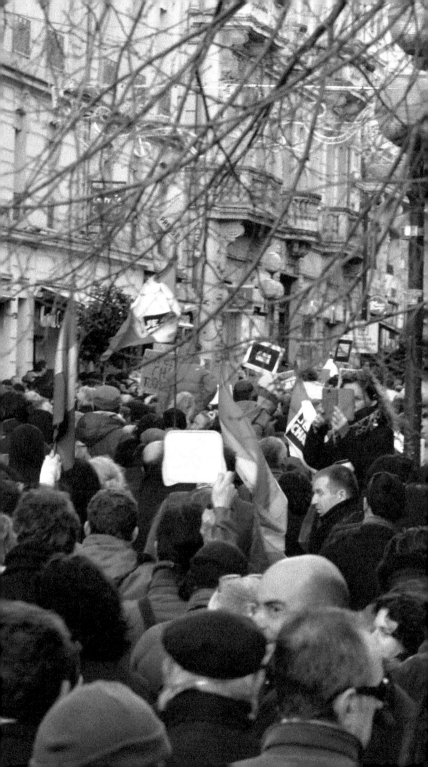

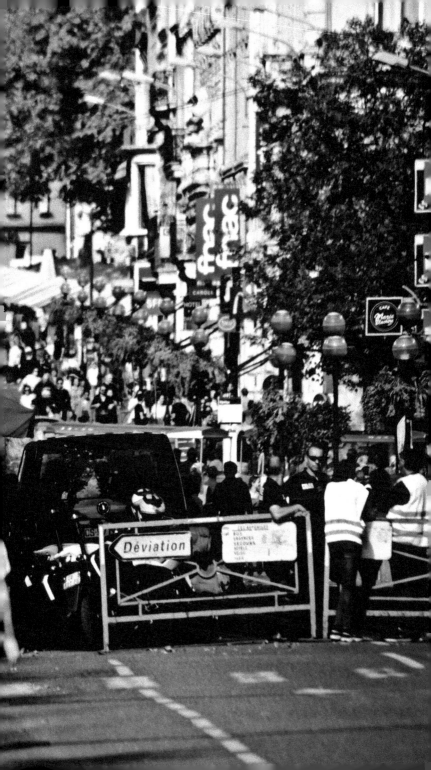

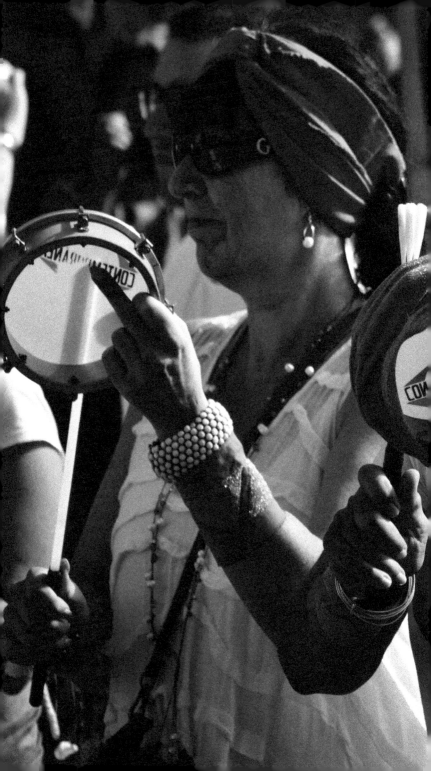

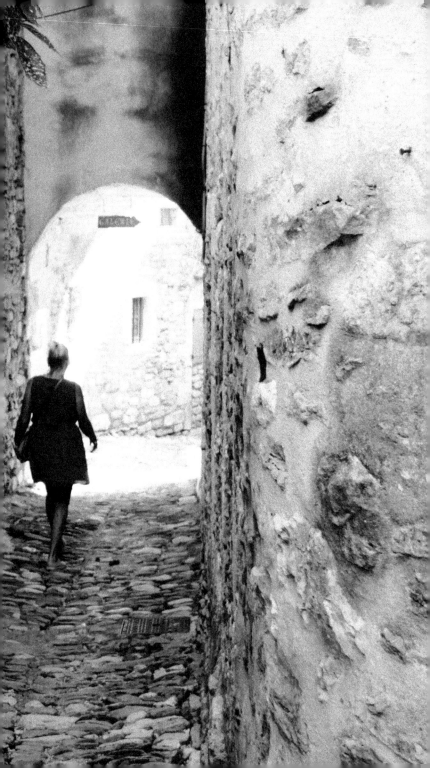

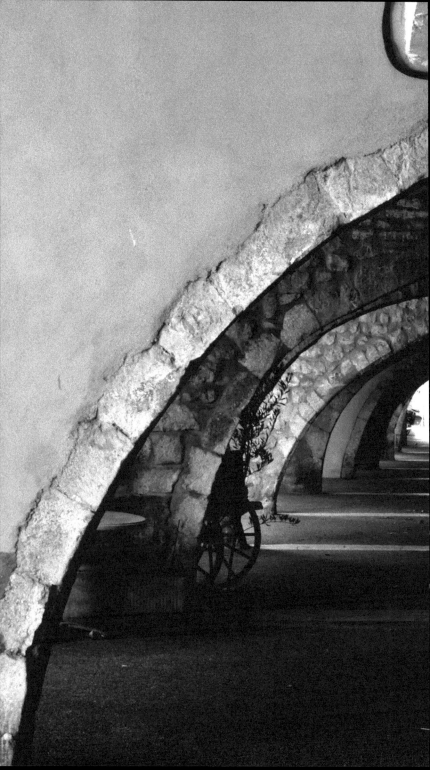

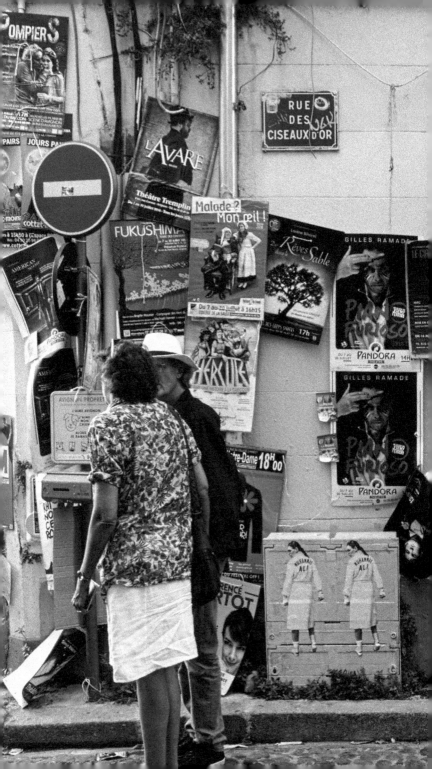

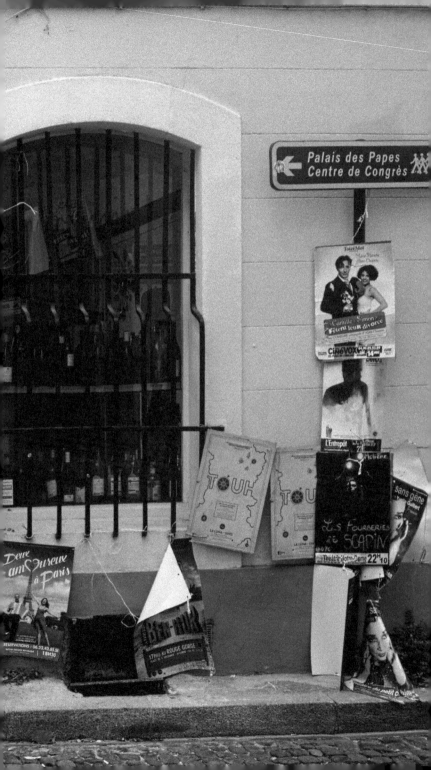

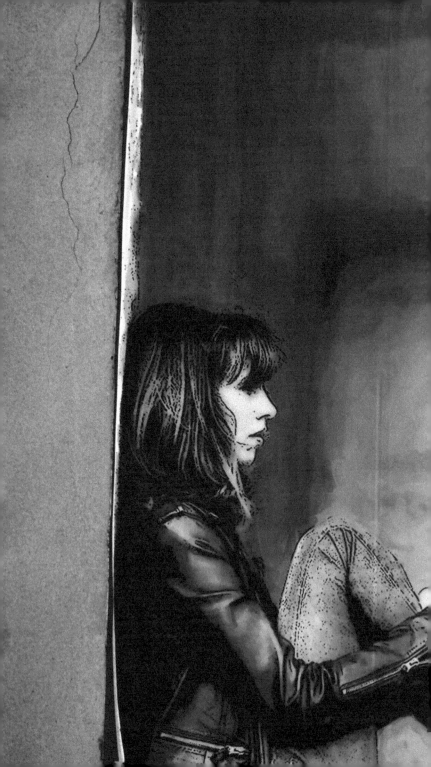

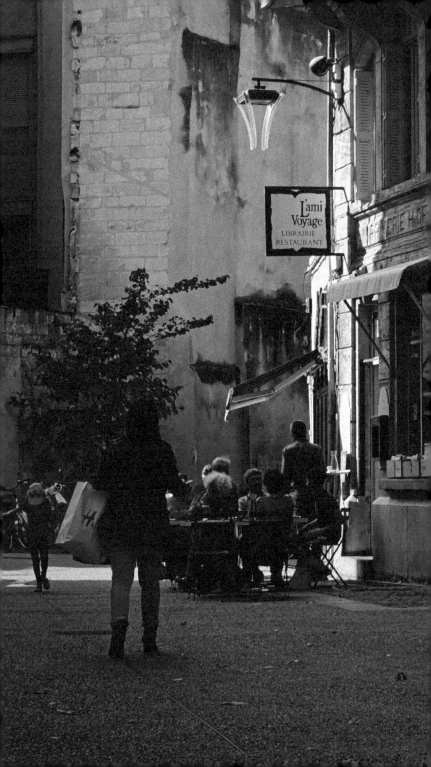

LA SOLUTION
NE VIENDRA
PAS D'EN HAUT

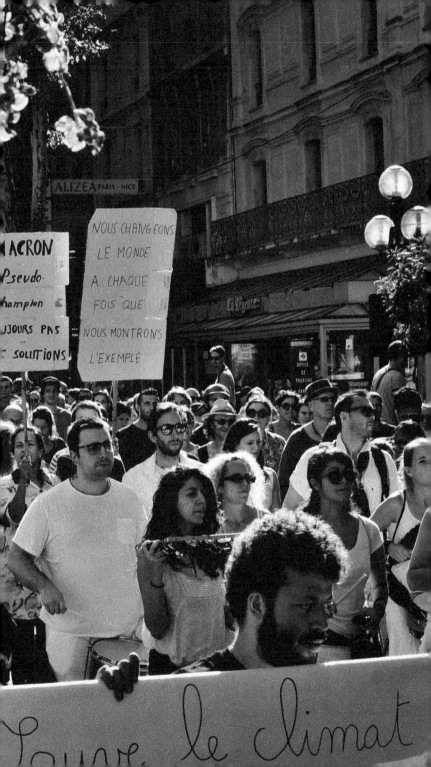

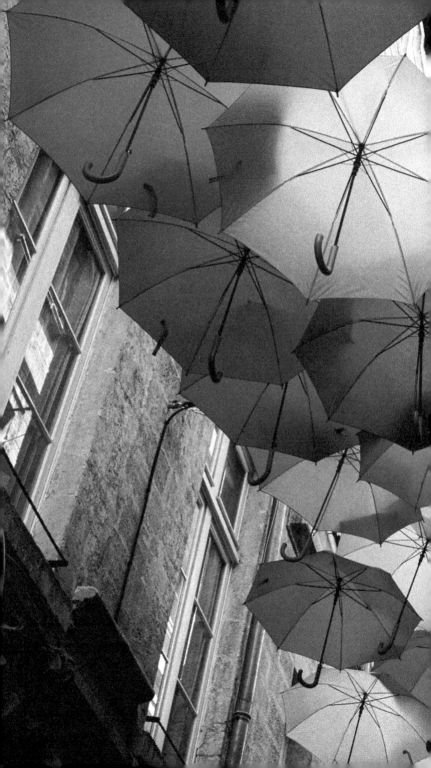

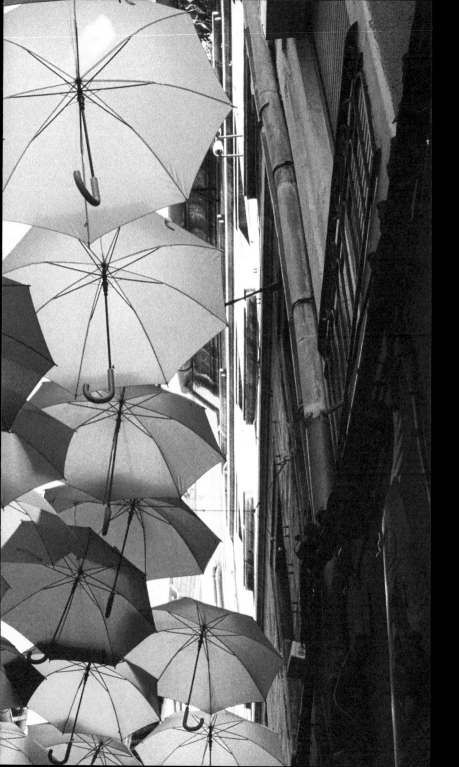

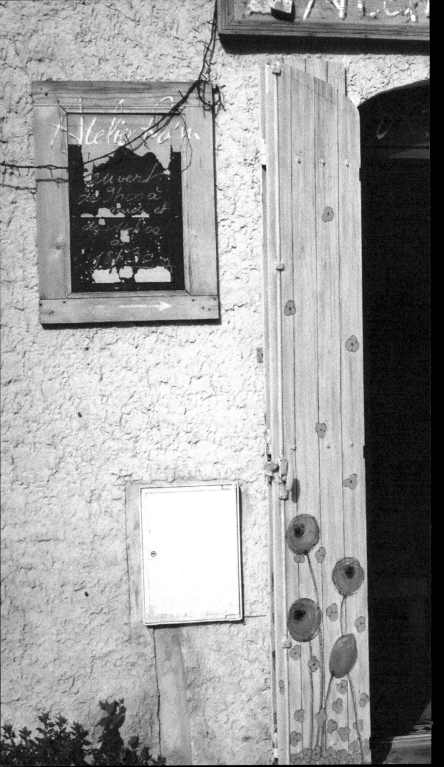

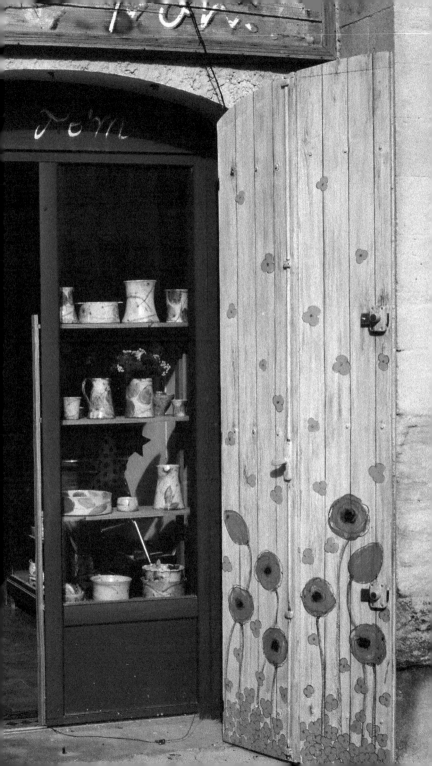

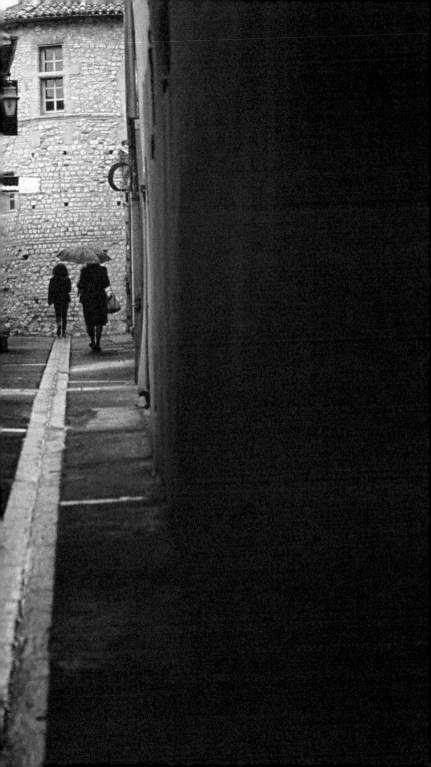

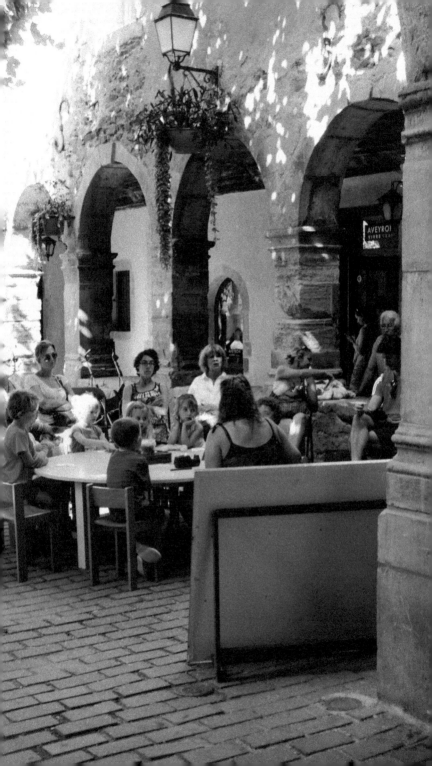

BAR à ÉPICES
TERRASSE
JUS de FRUITS

SANDWICHES SAVEUR

SALADES Fraicheur
TARTINES Gourmandes
PETIT DEJEUNER
COMPLET

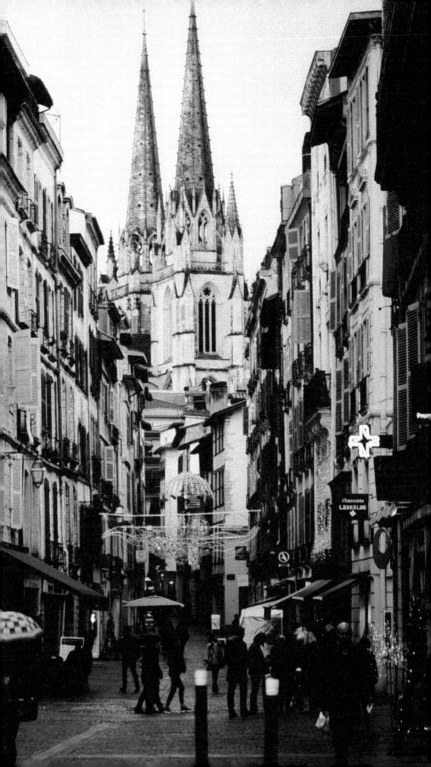

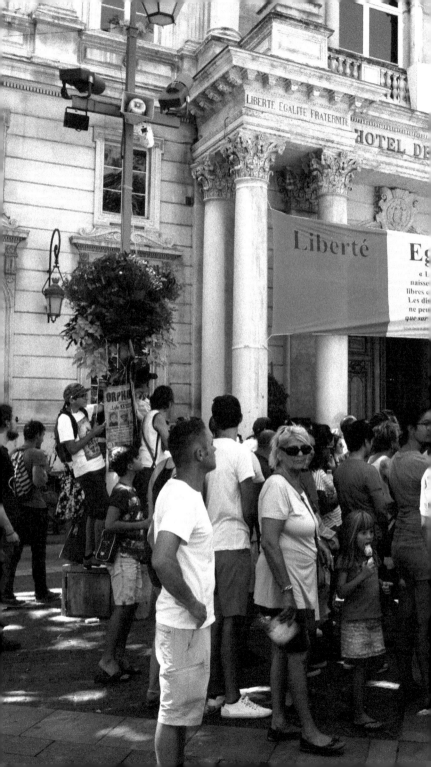

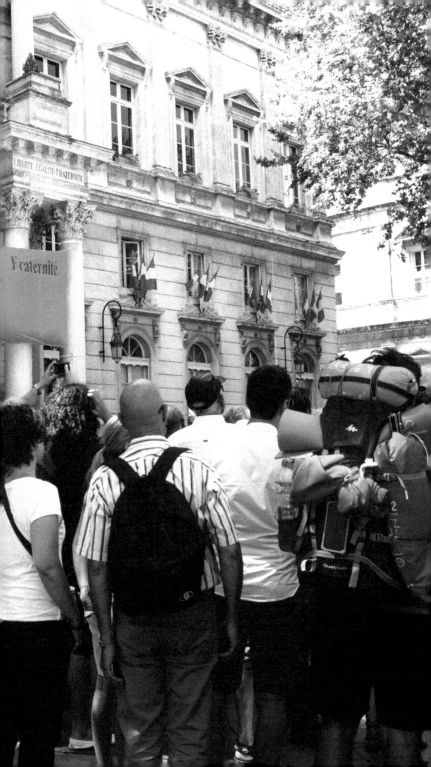

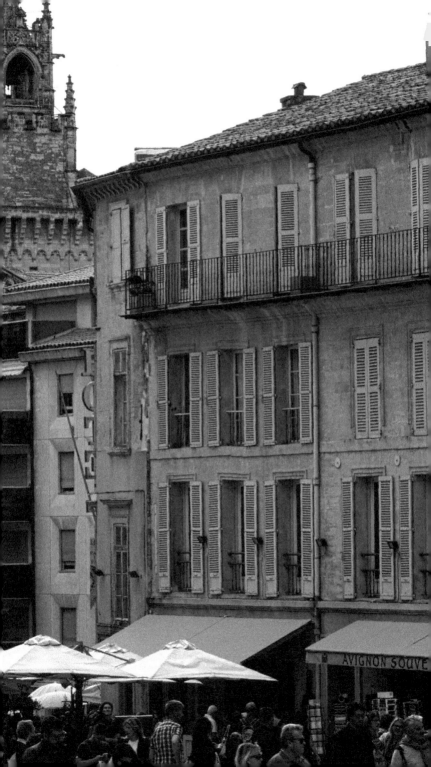

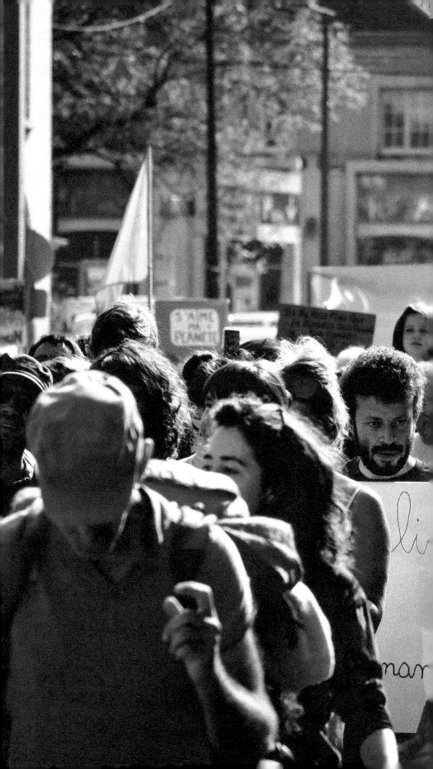

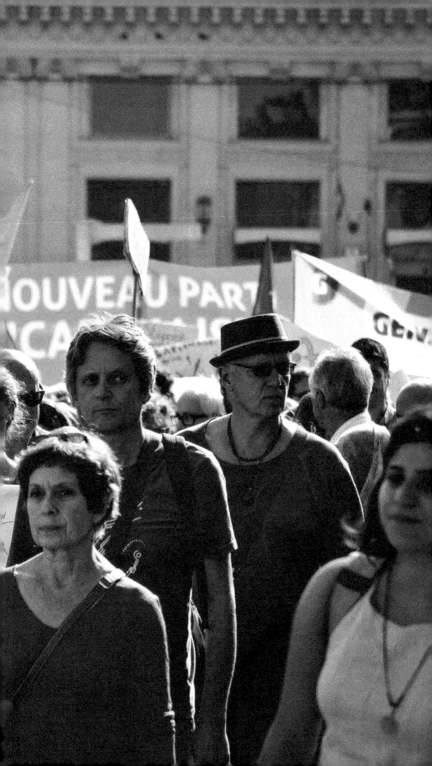

CPSIA information can be obtained
at www.ICGtesting.com
Printed in the USA
BVHW022003280719
554531BV00010B/314/P

9 780464 092216